Exotic Beauty

Adult
Coloring Book

by
Tabz Jones

SPECIAL THANKS

Special thanks go to ambient-avalancher @DeviantArt.com for permission to use his beautiful women to create this book. If you like this book, please stop by his page and let him know!

http://ambient-avalancher.deviantart.com/

Copyright © 2016 by Tabz Jones

All rights reserved. This book or any portion thereof

may not be reproduced or used in any manner whatsoever

without the express written permission of the author

except for the use of brief quotations in a book review.

Printed in the United States of America

First Printing, 2016

ISBN-13: 978-1537767567

ISBN-10: 1537767569

Tabz Jones

PO BOX 2137

Alma AR 72921

www.gothictoggs.net

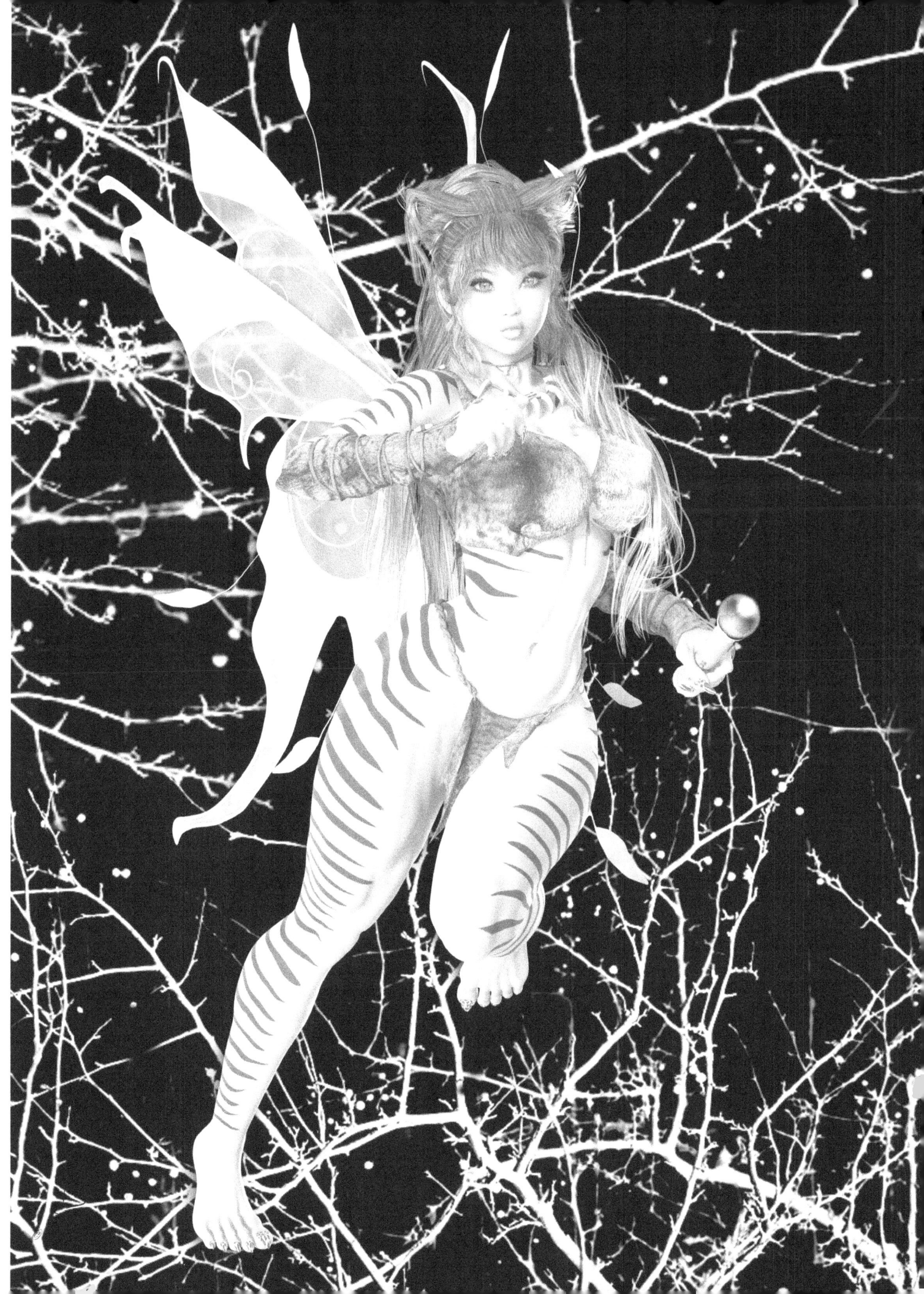

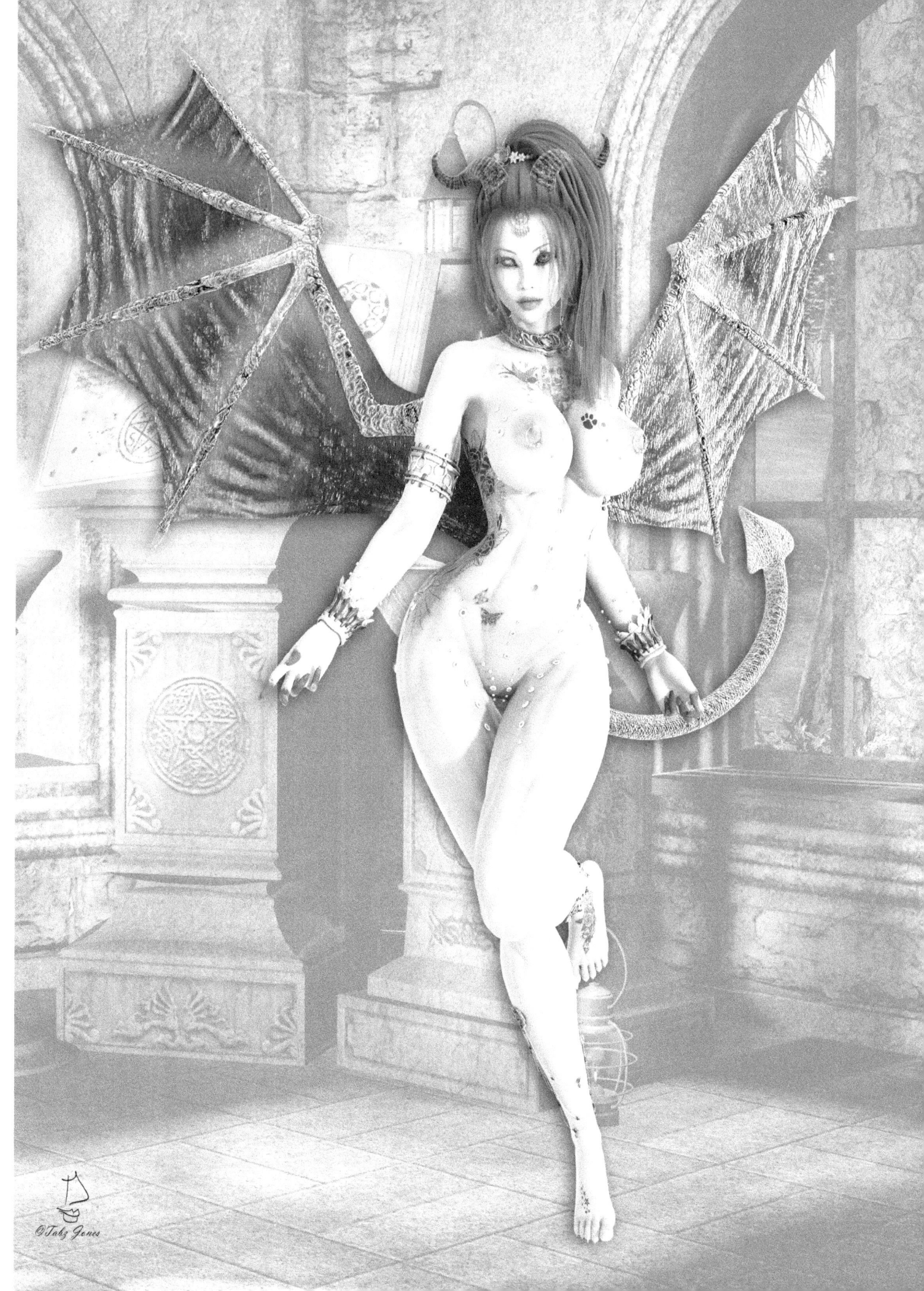

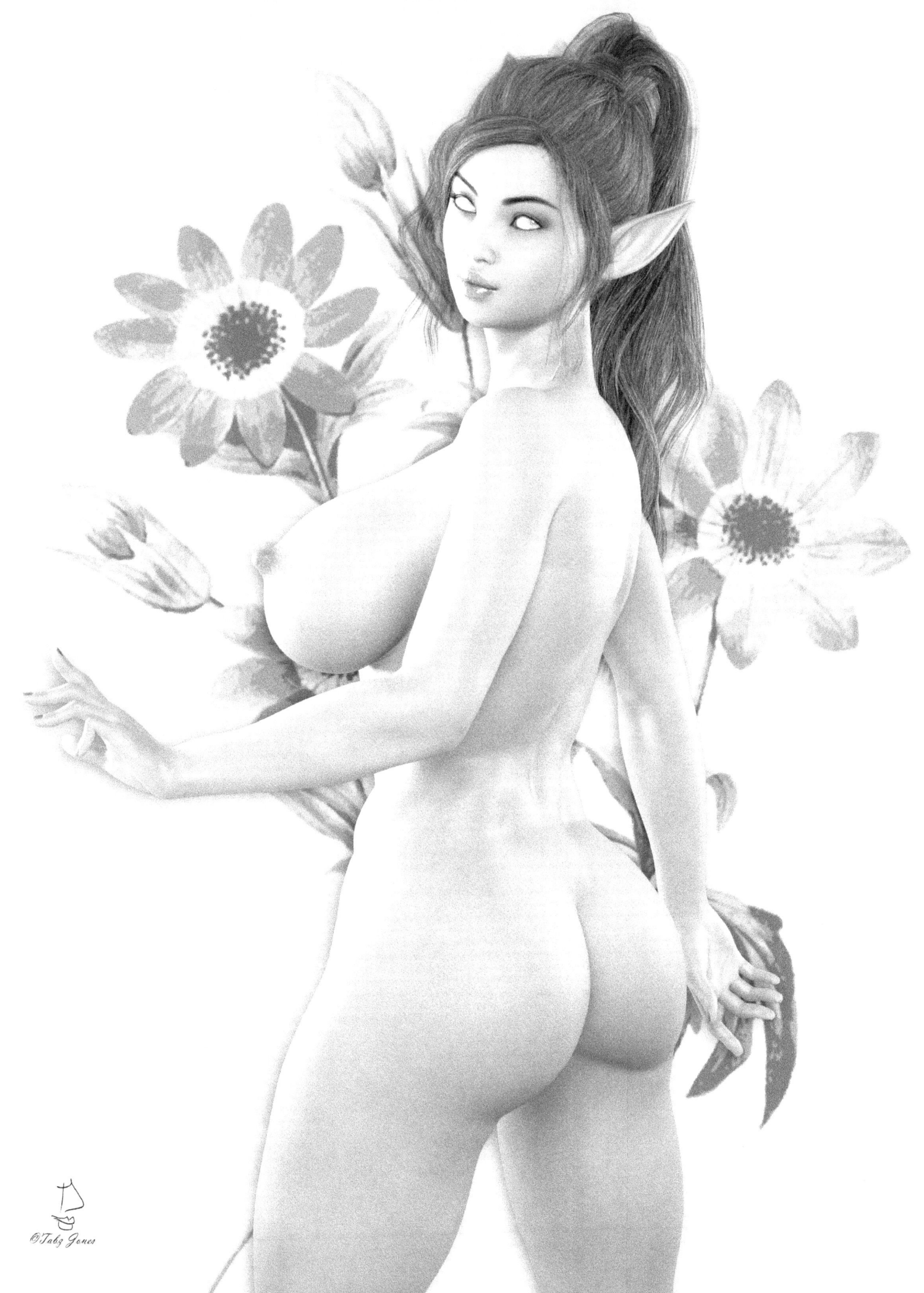

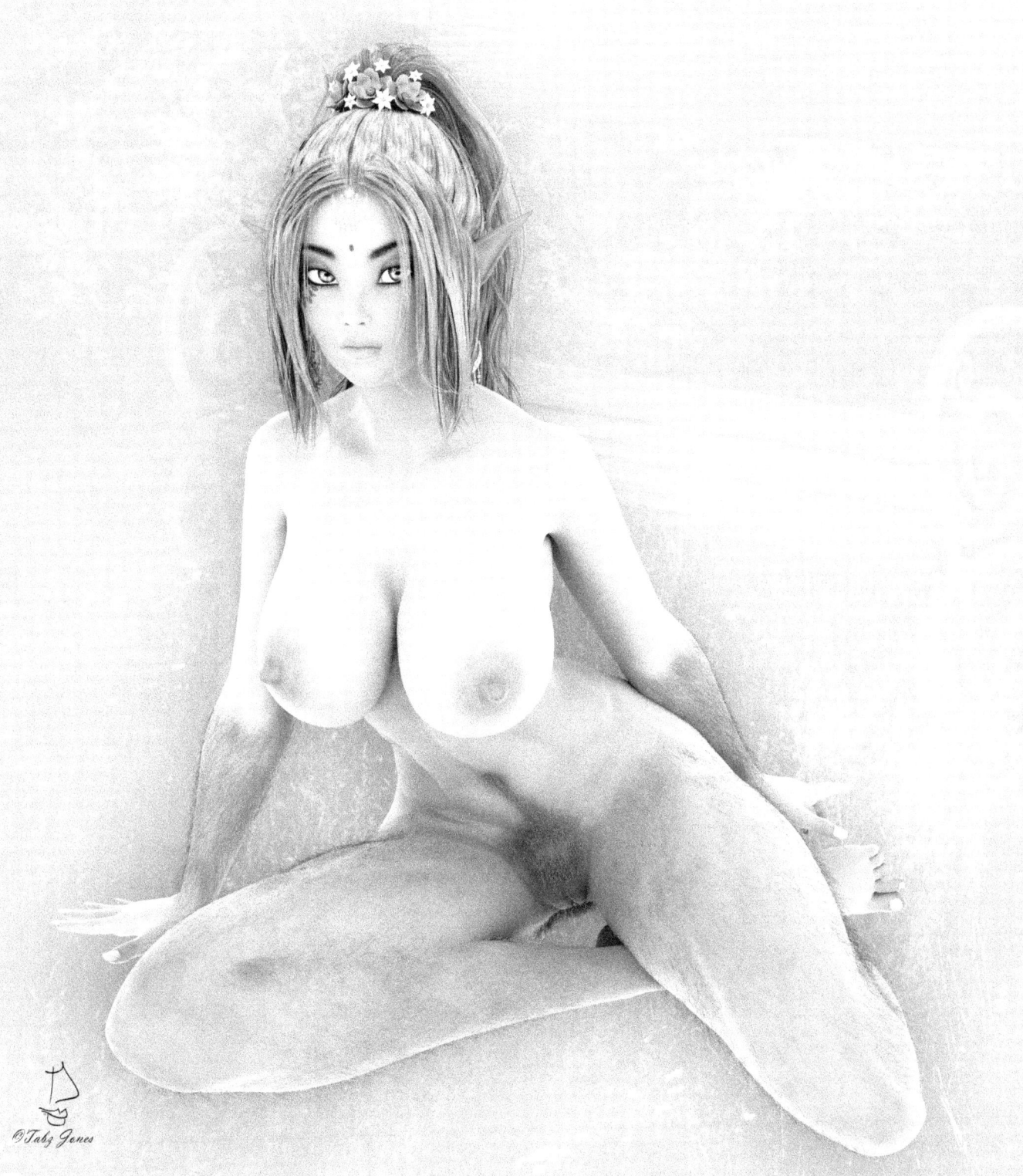

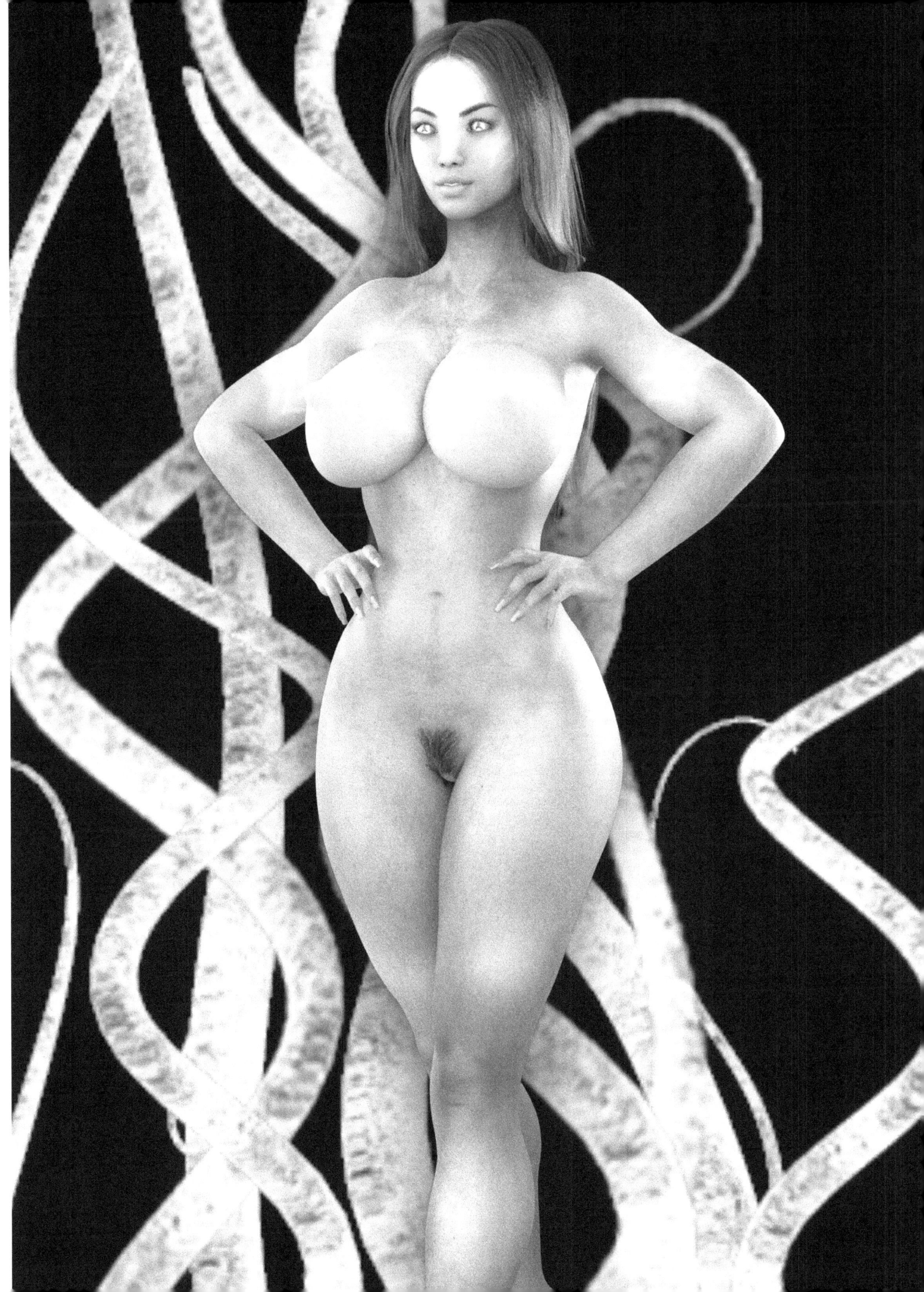

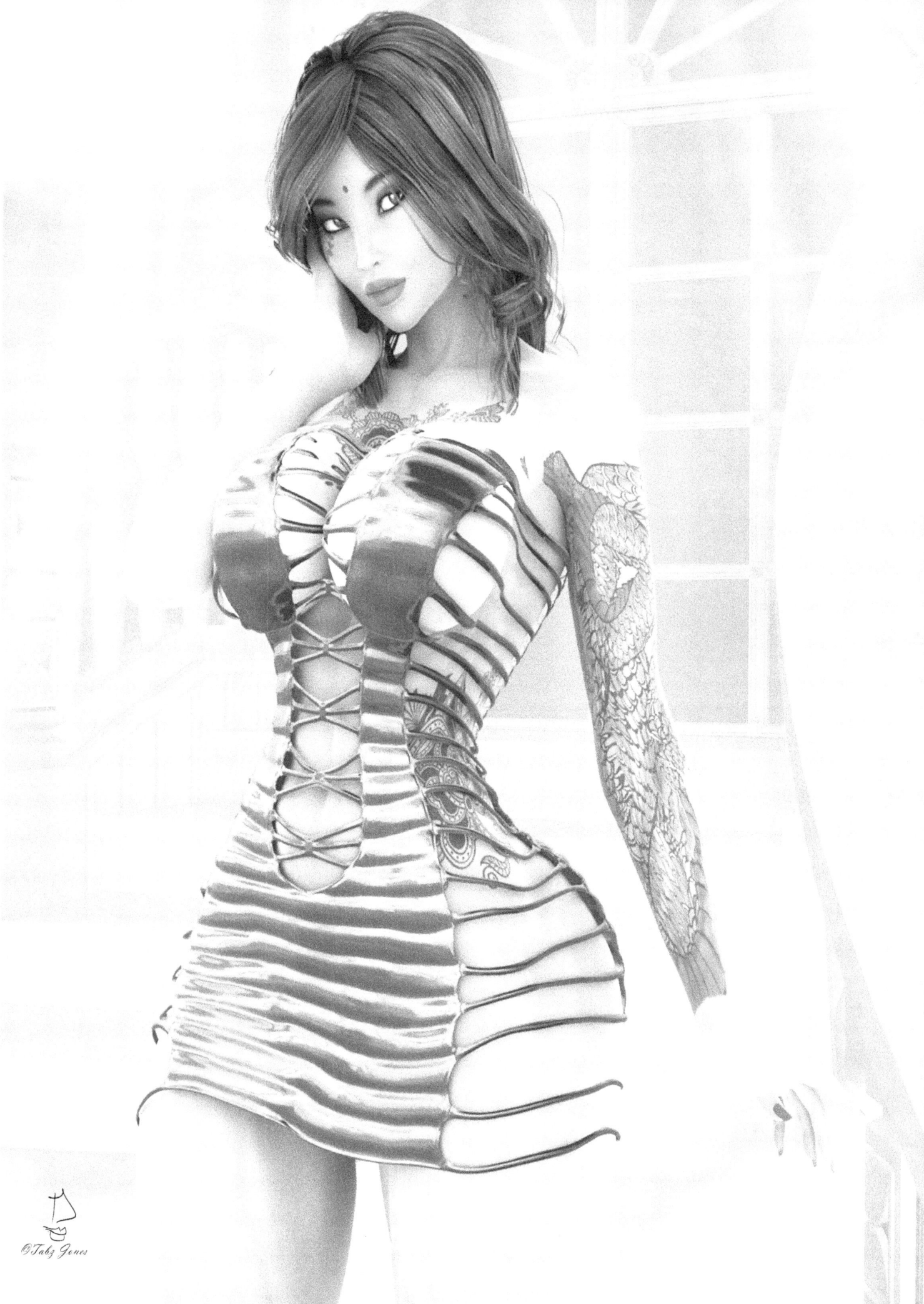

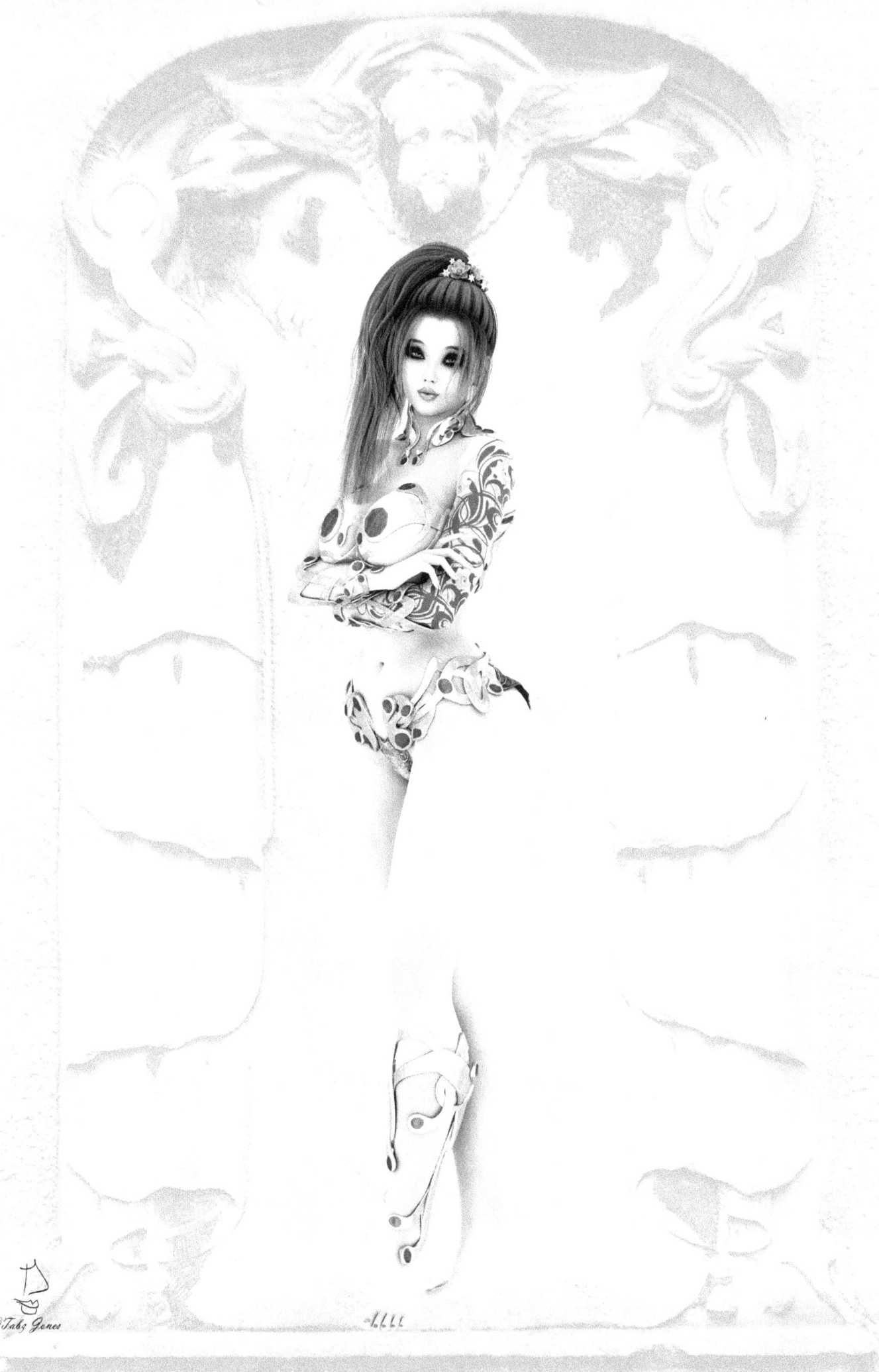

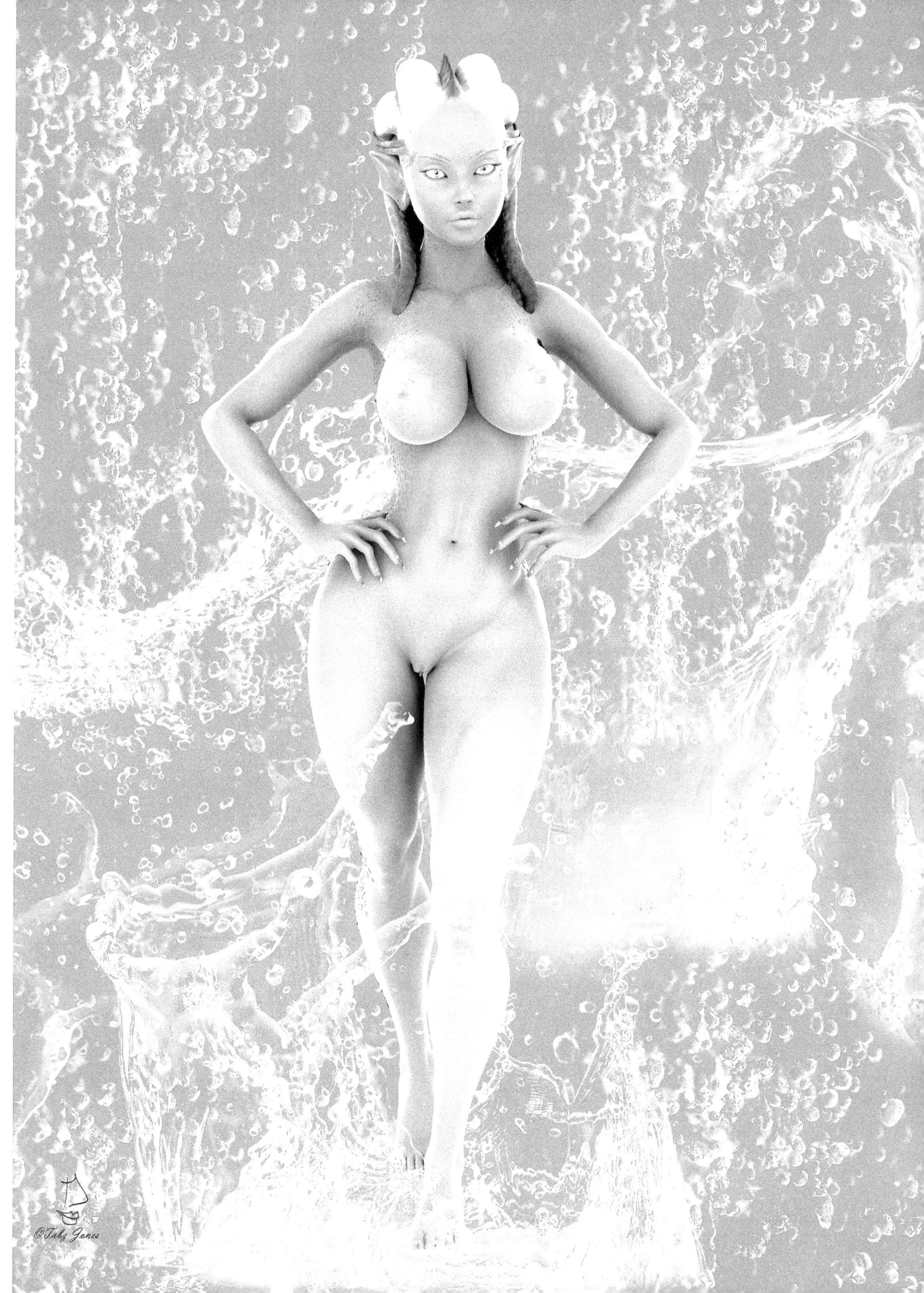

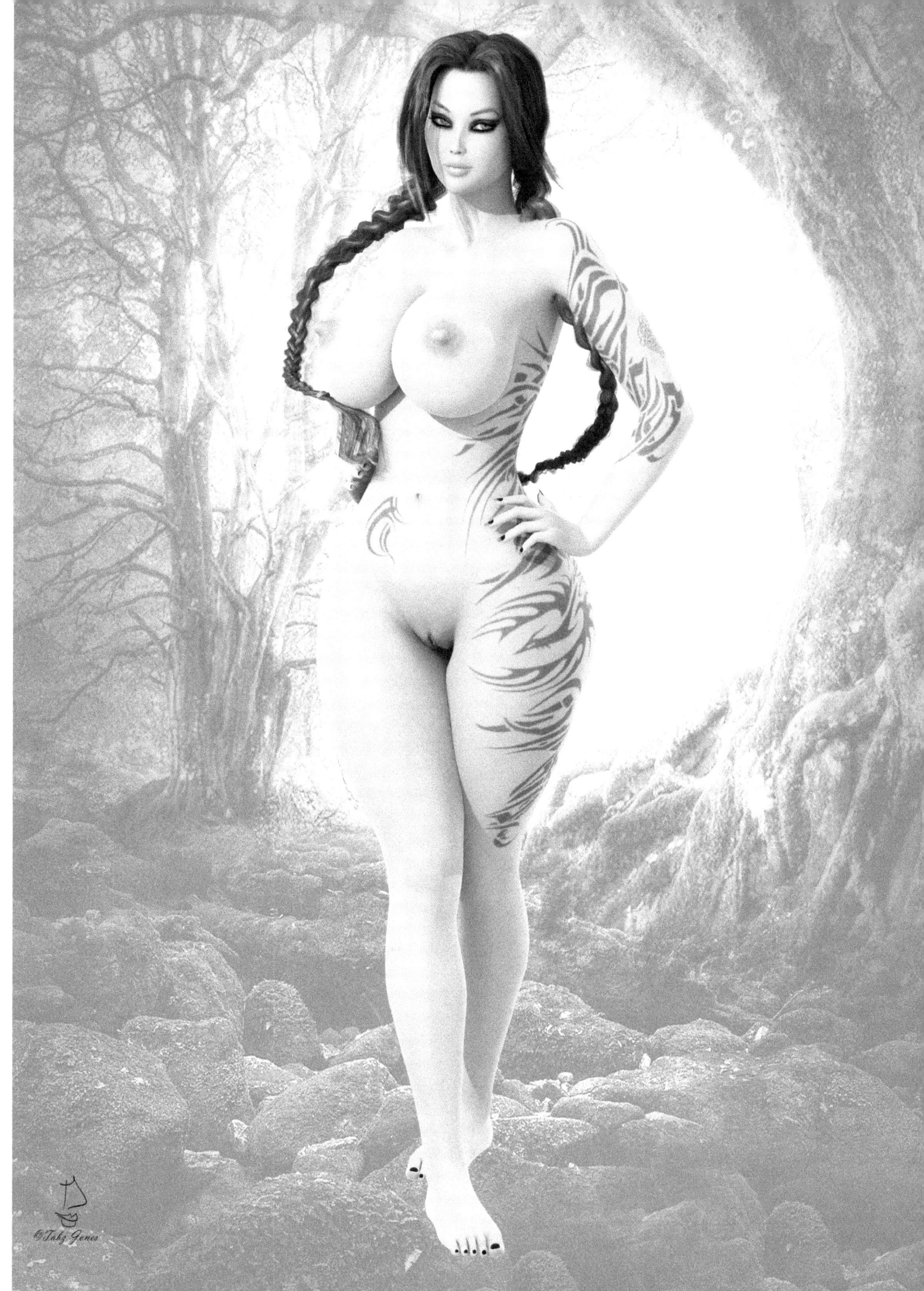

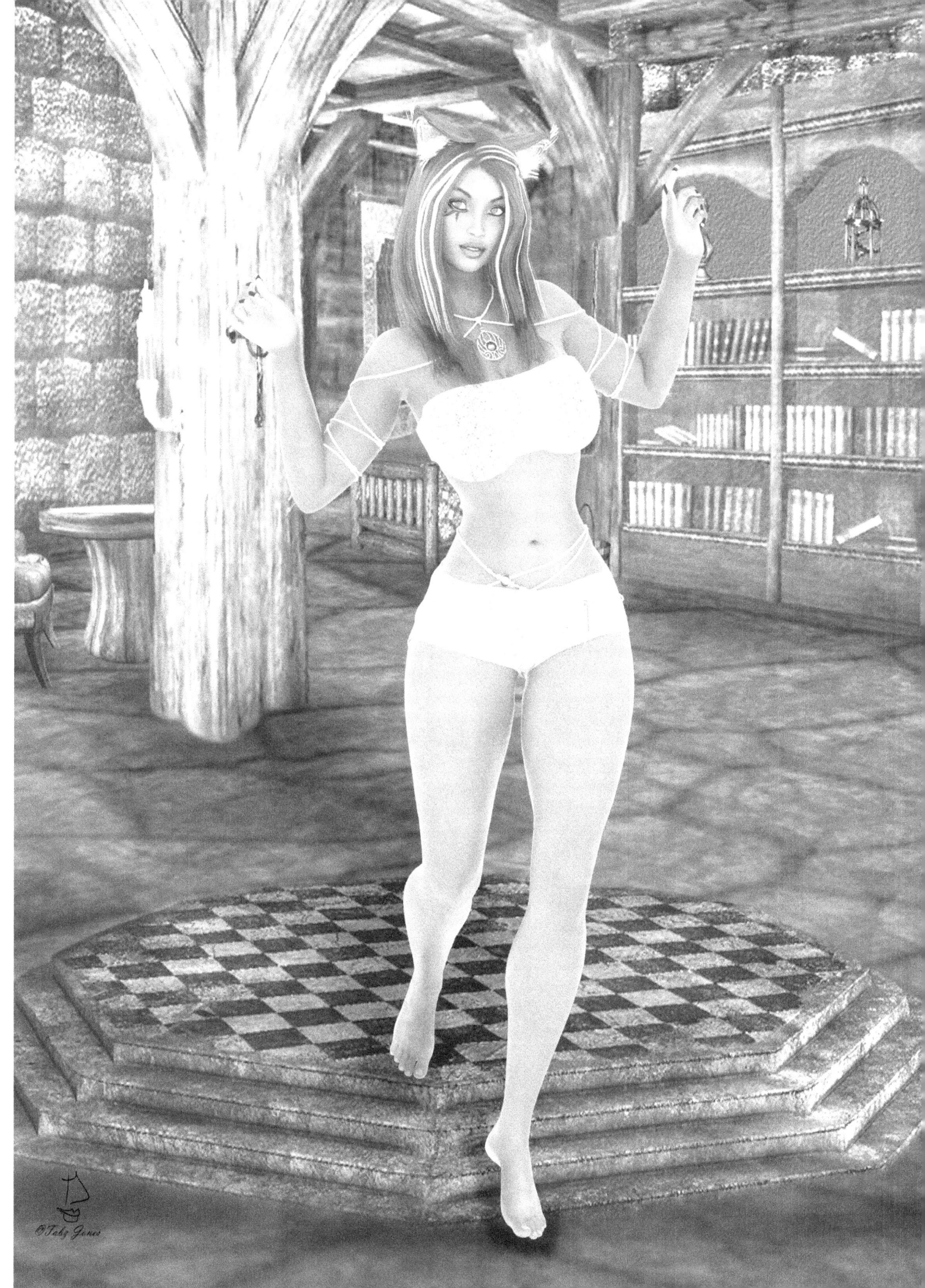

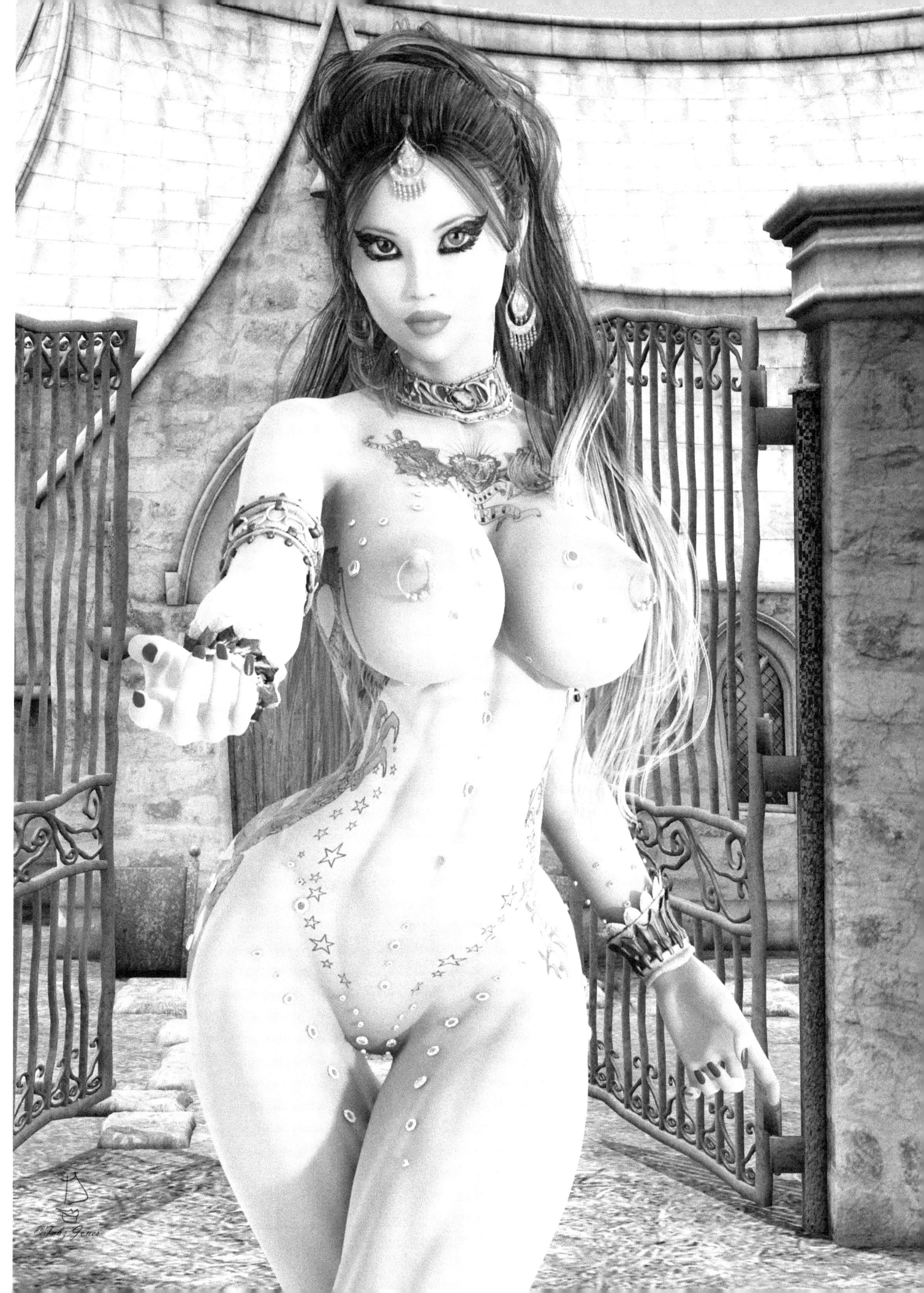

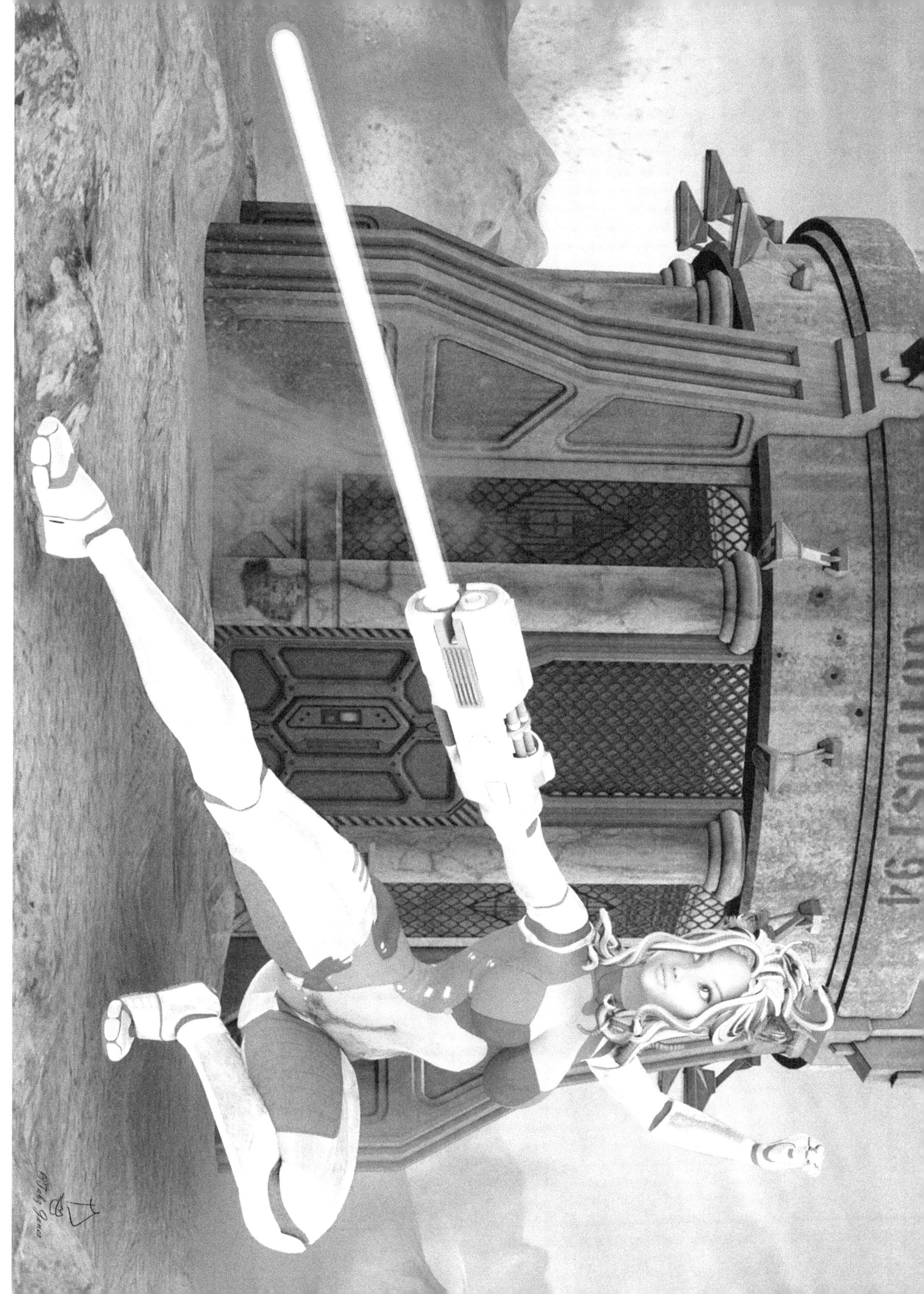

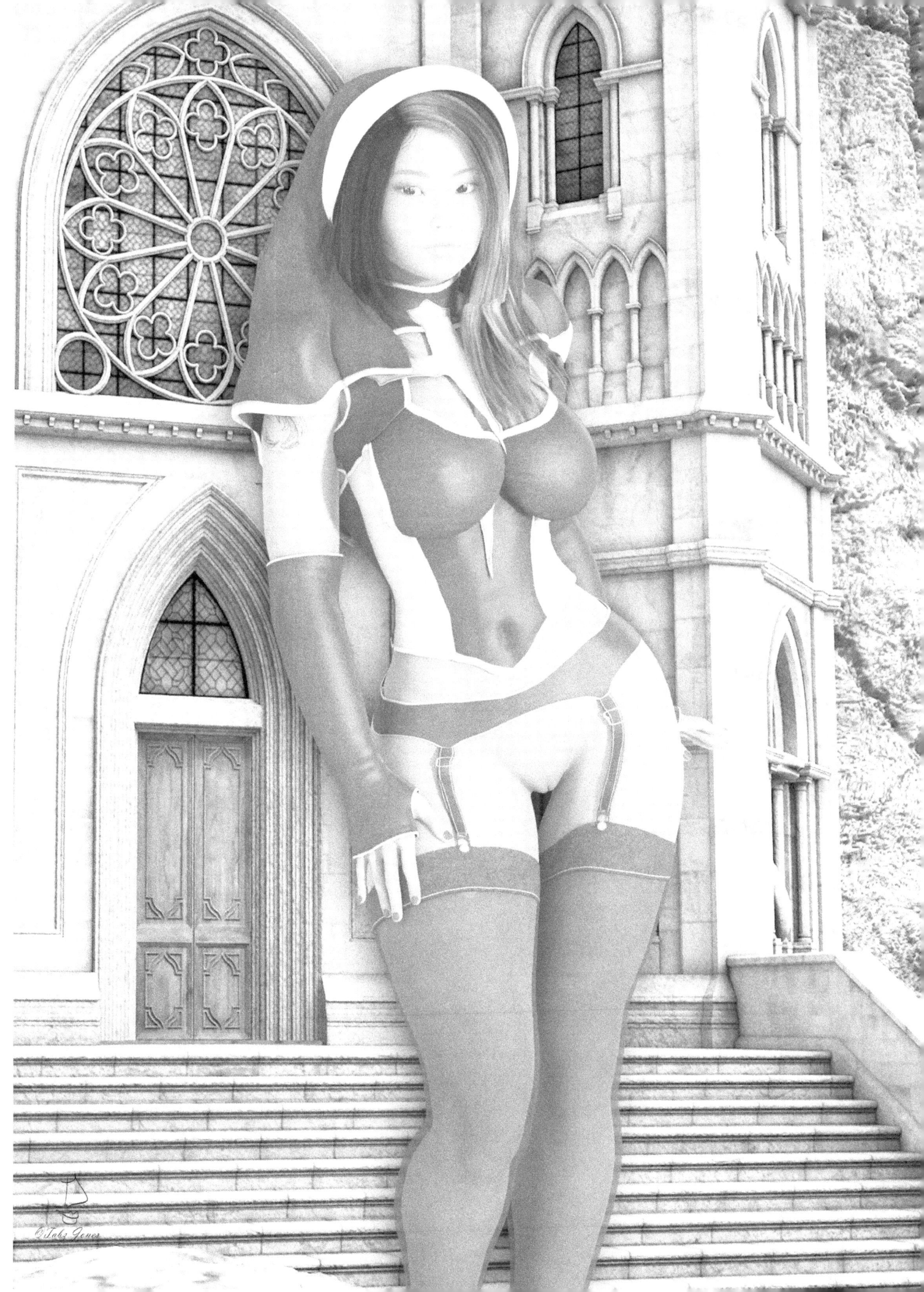

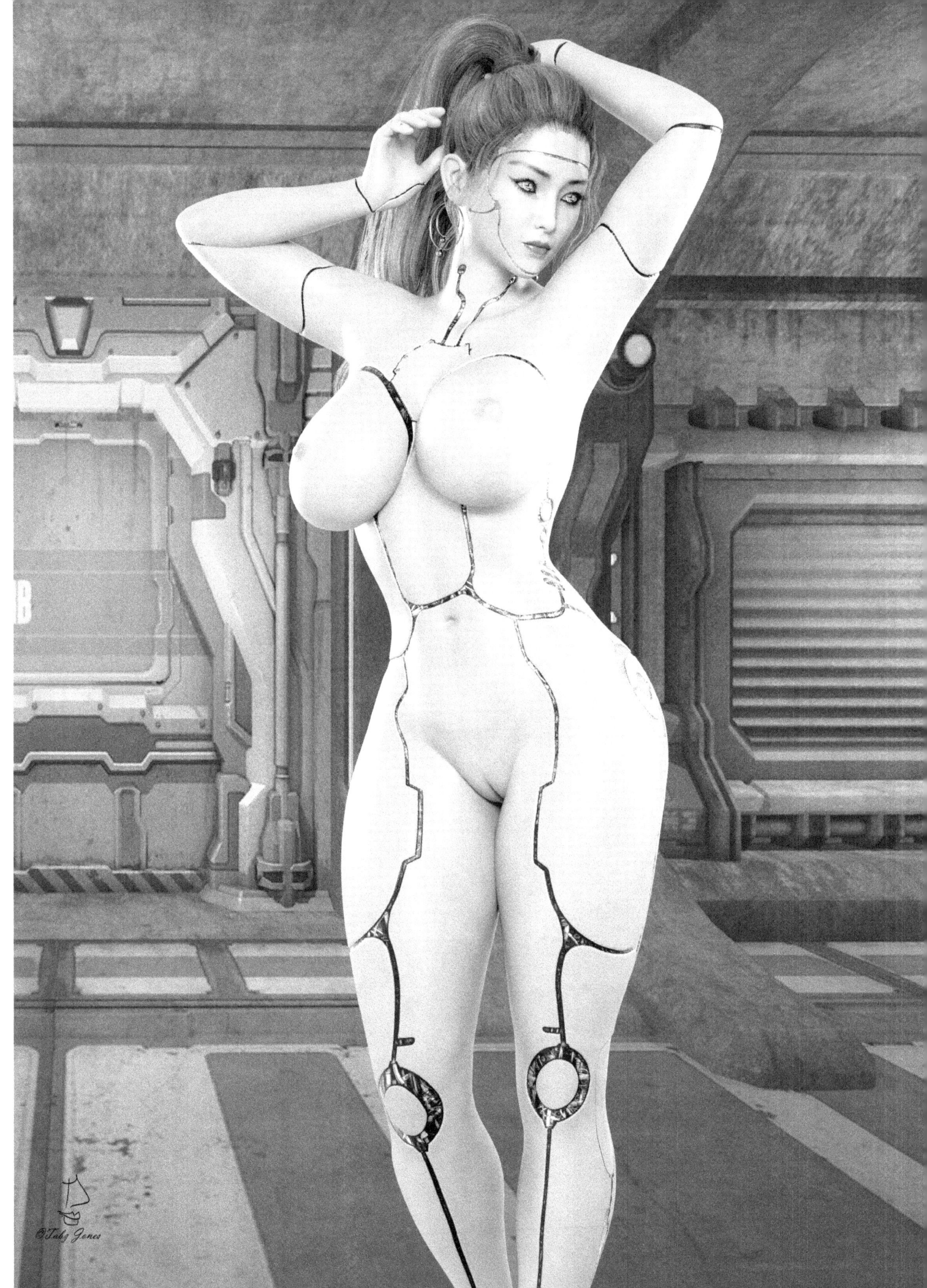

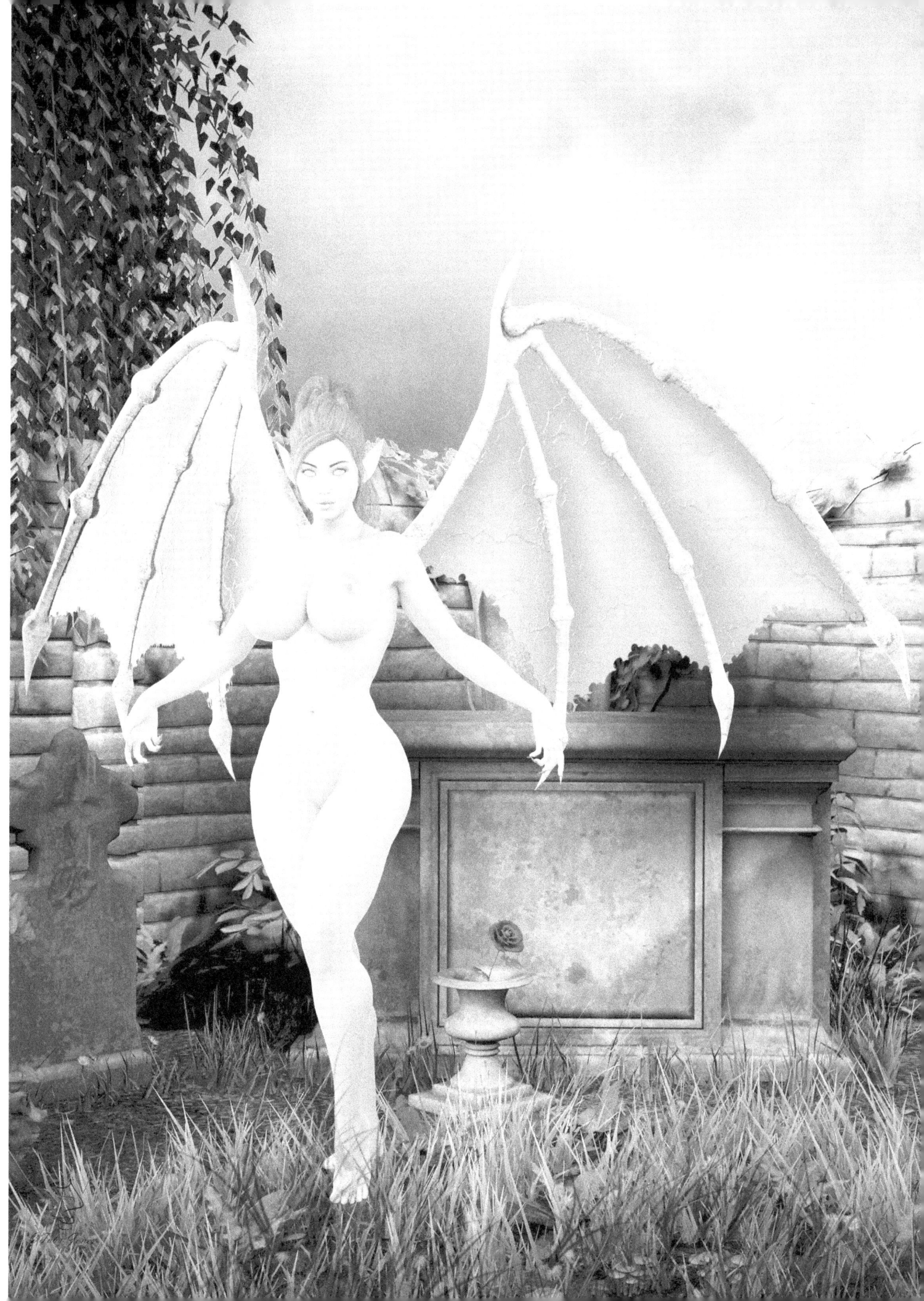

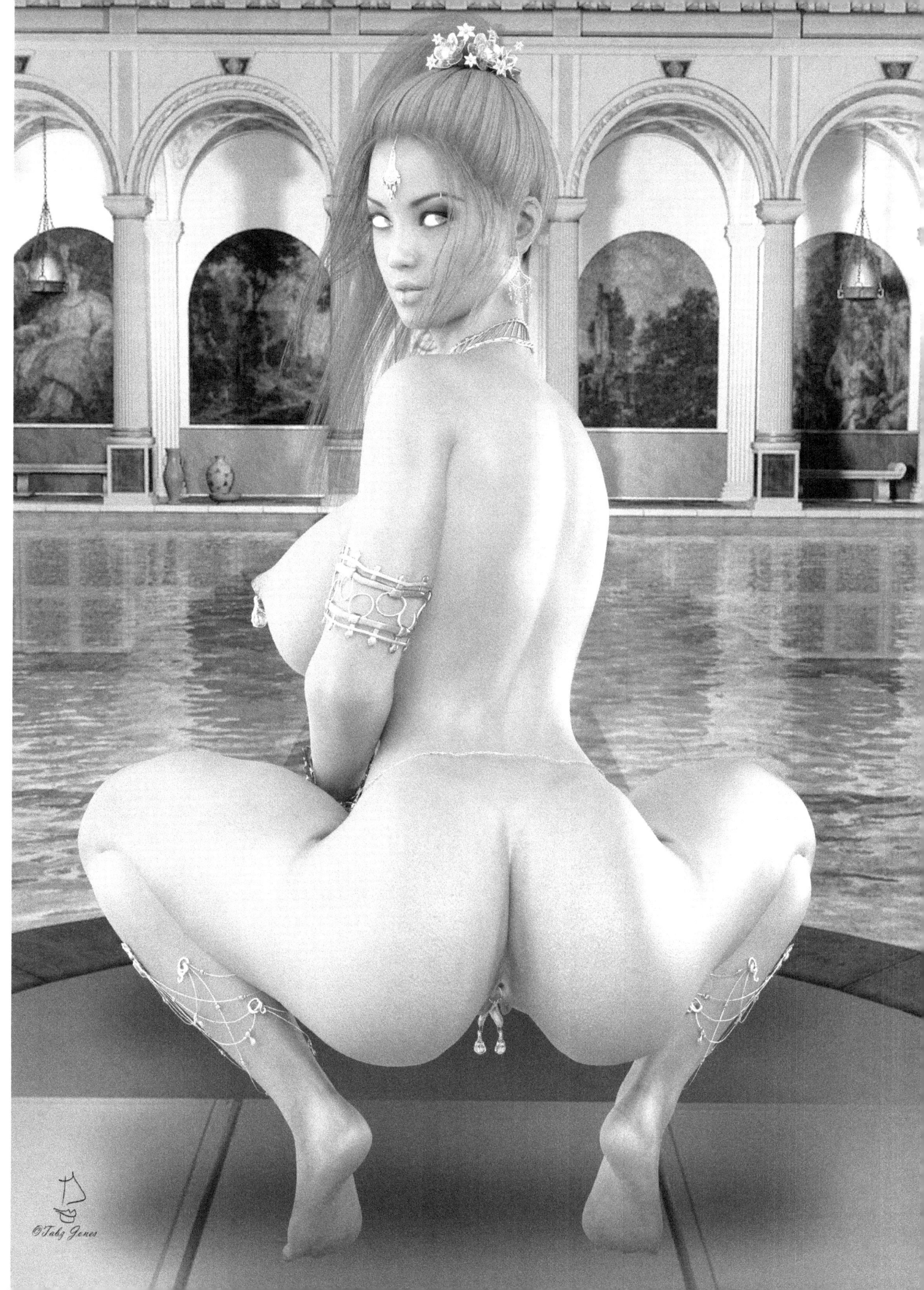

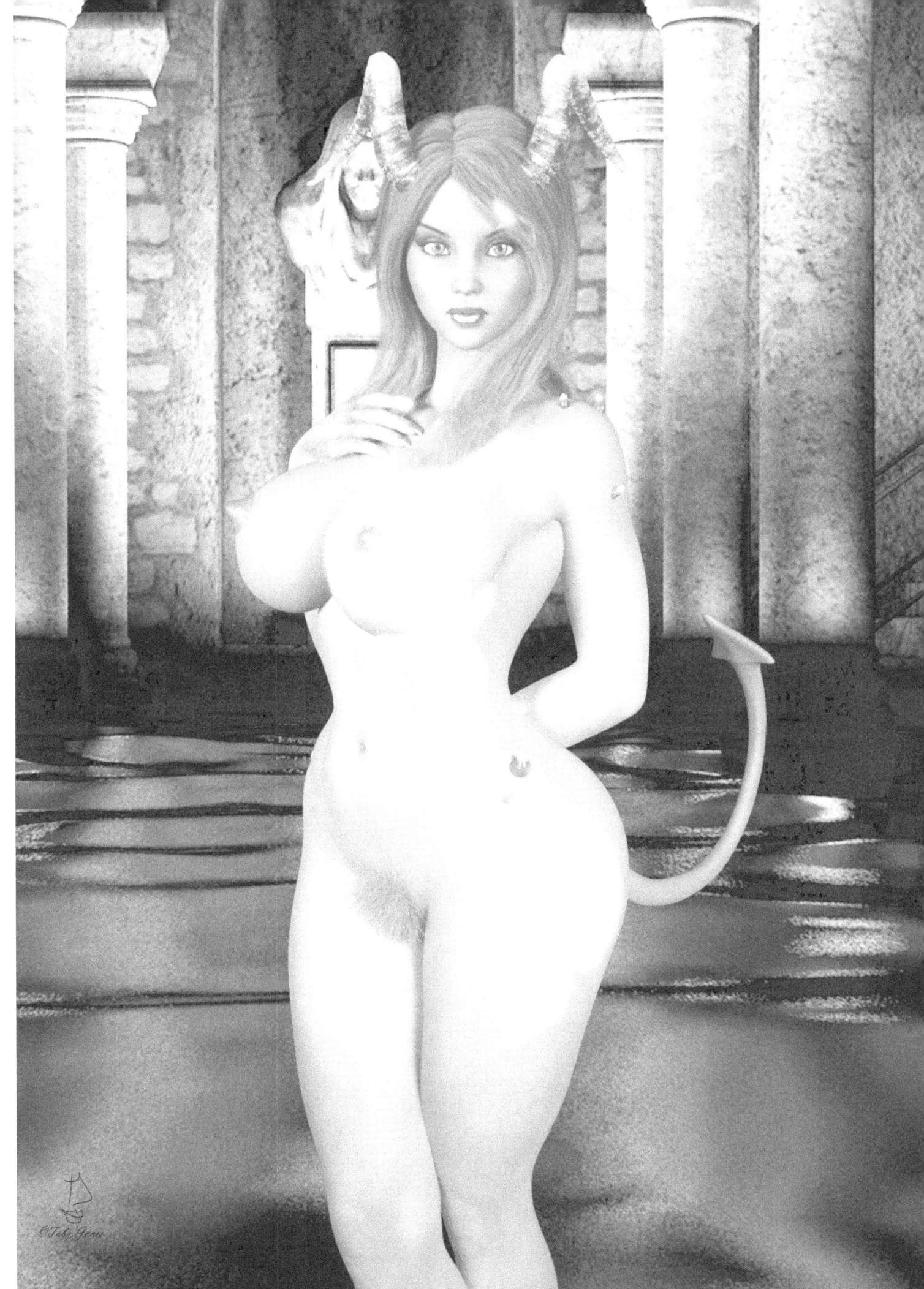

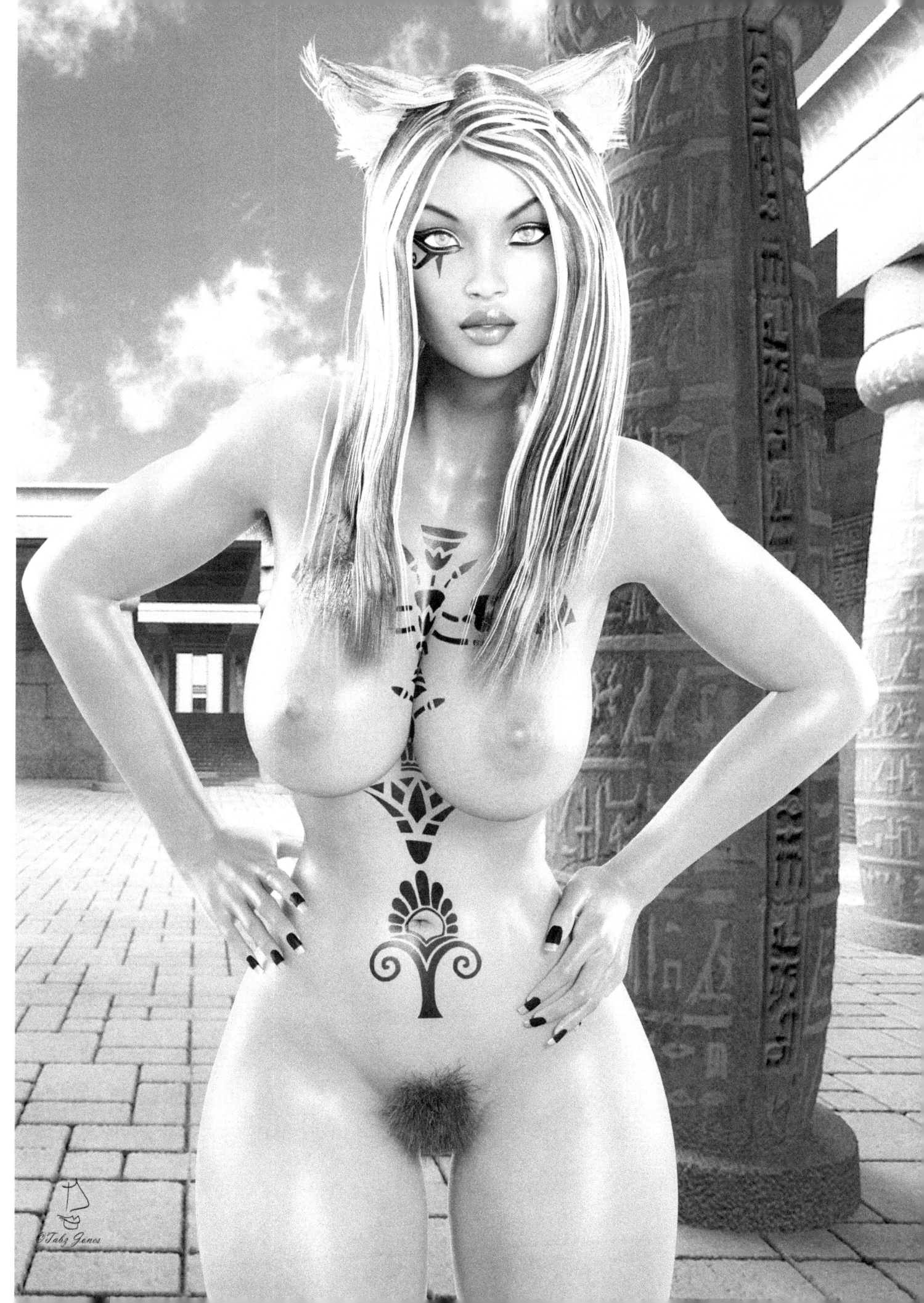

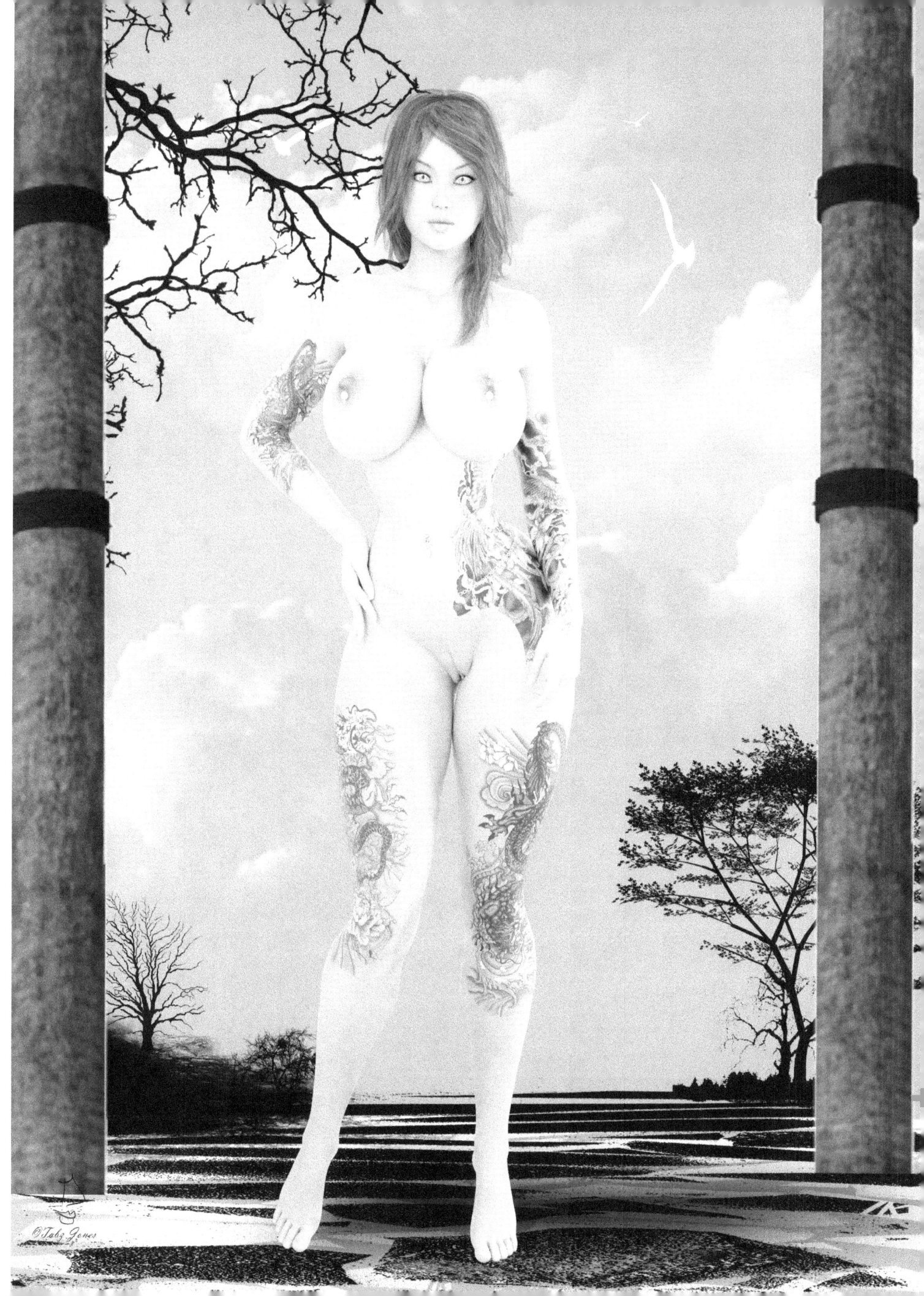

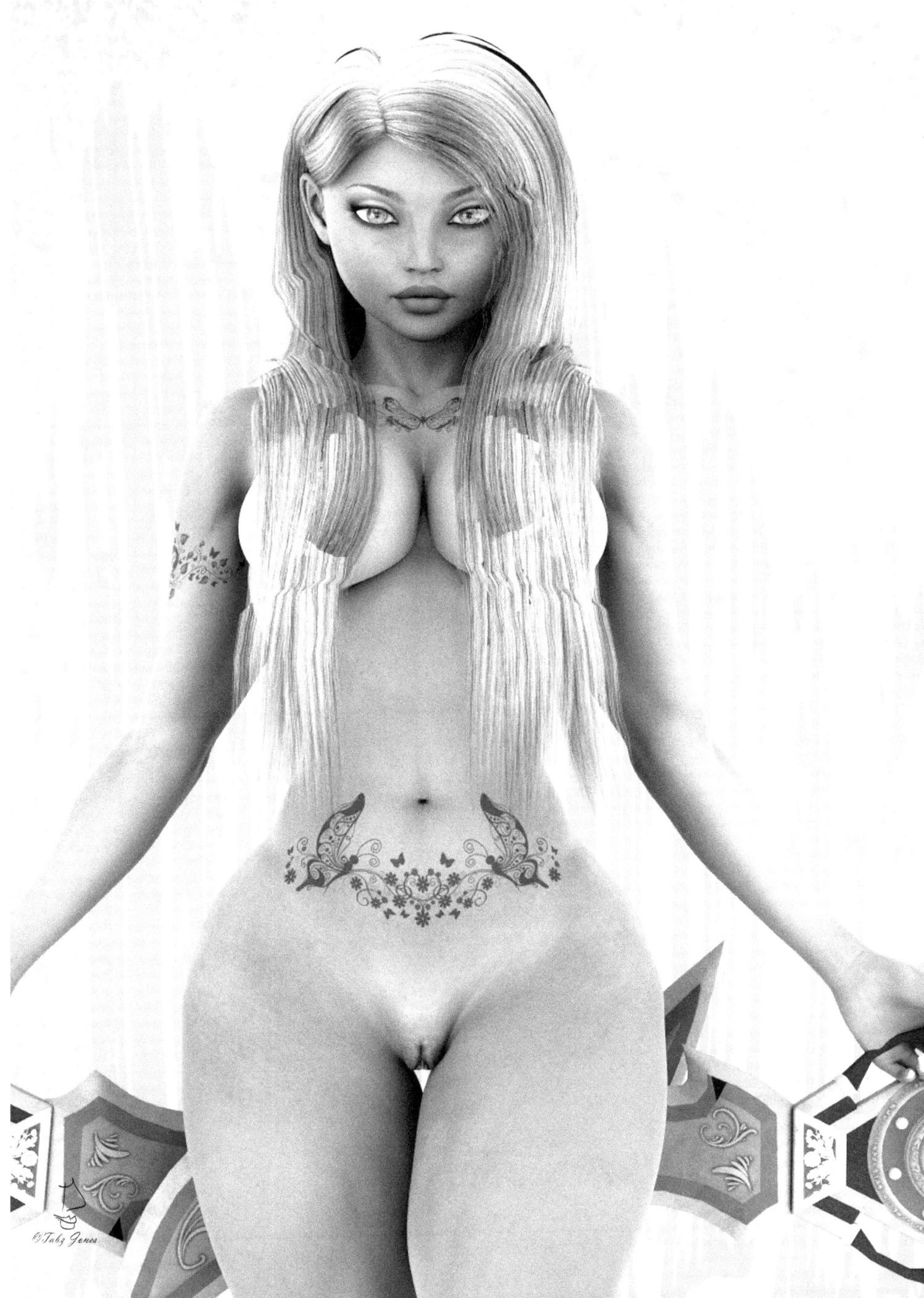

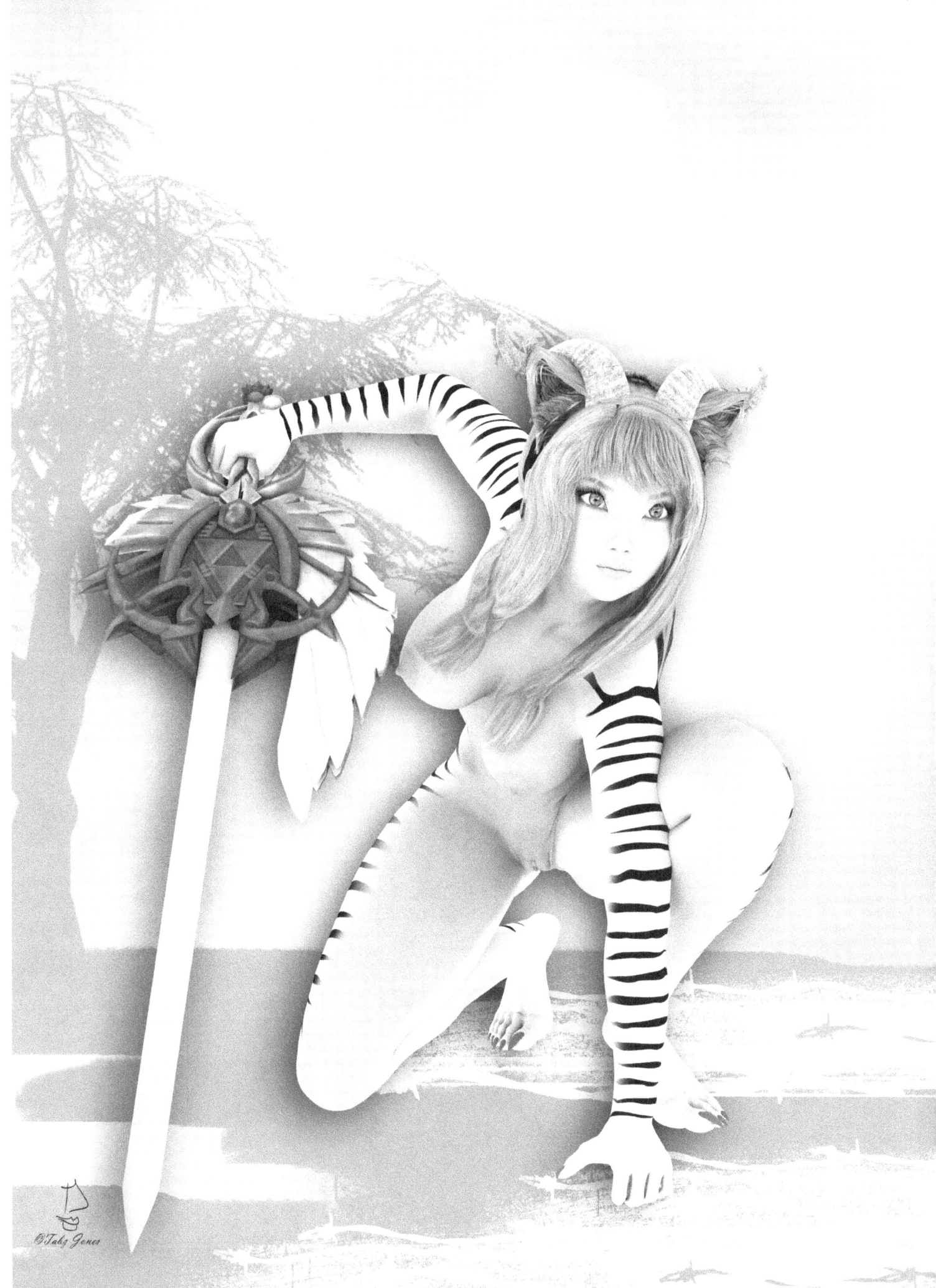

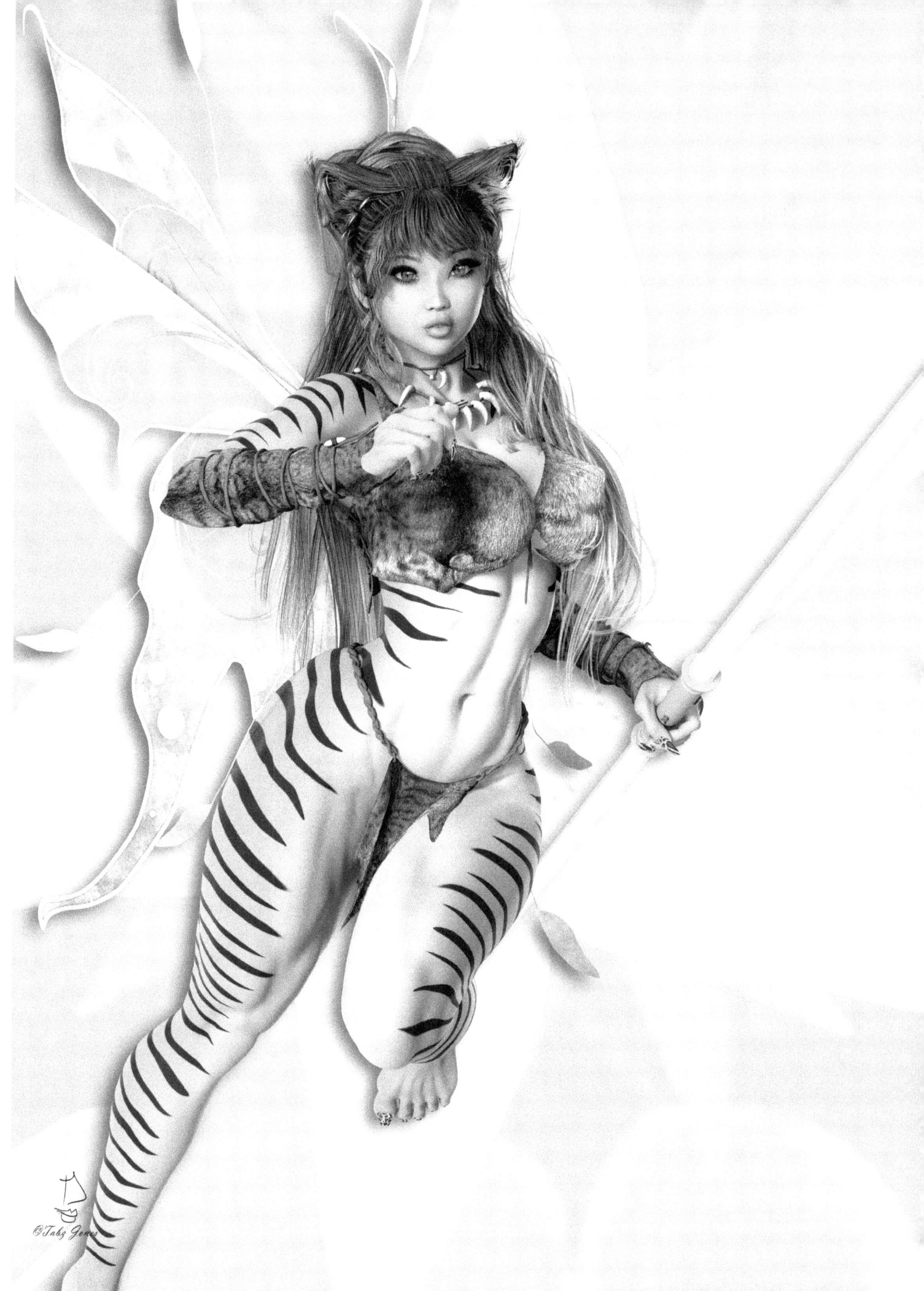

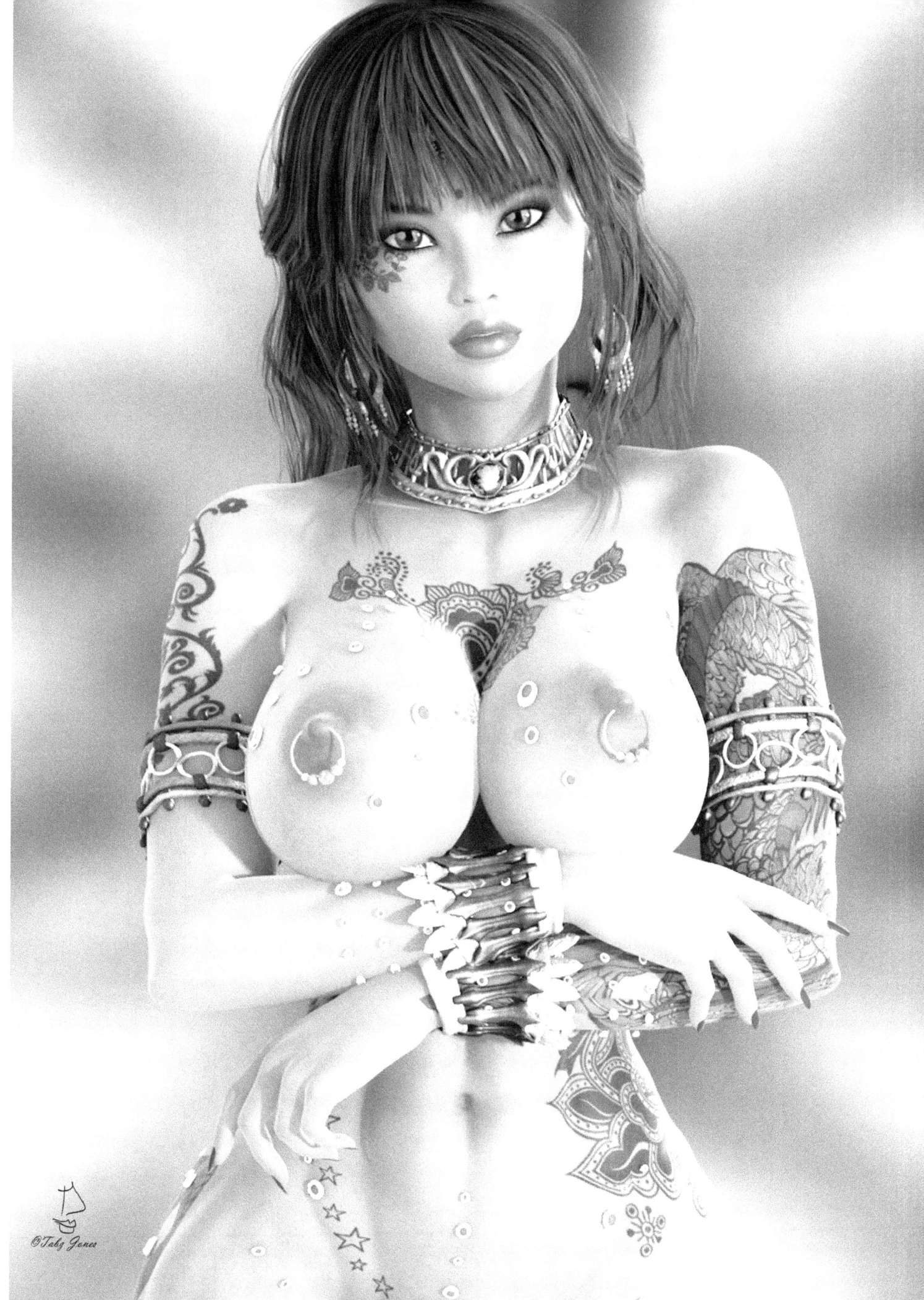

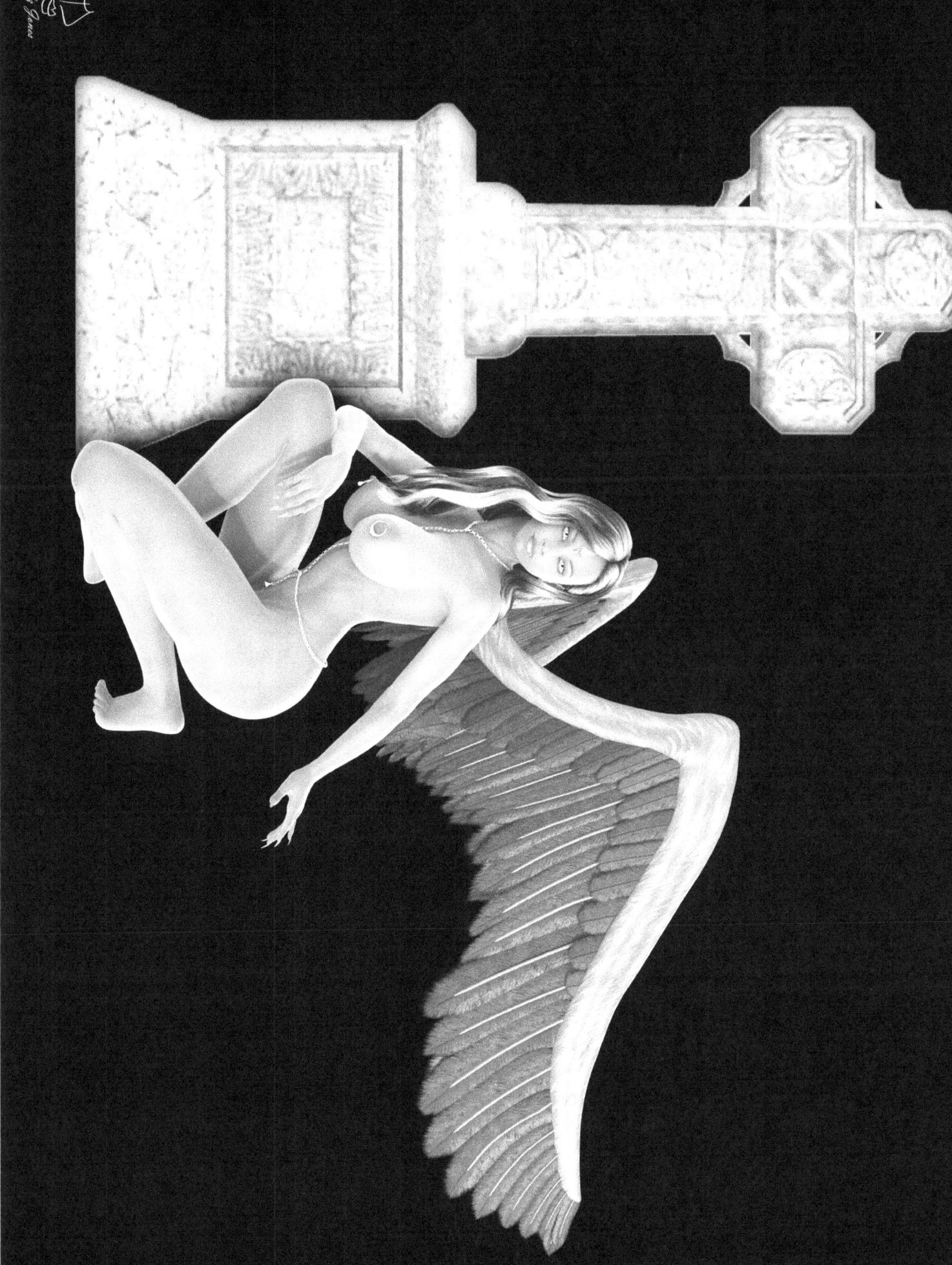

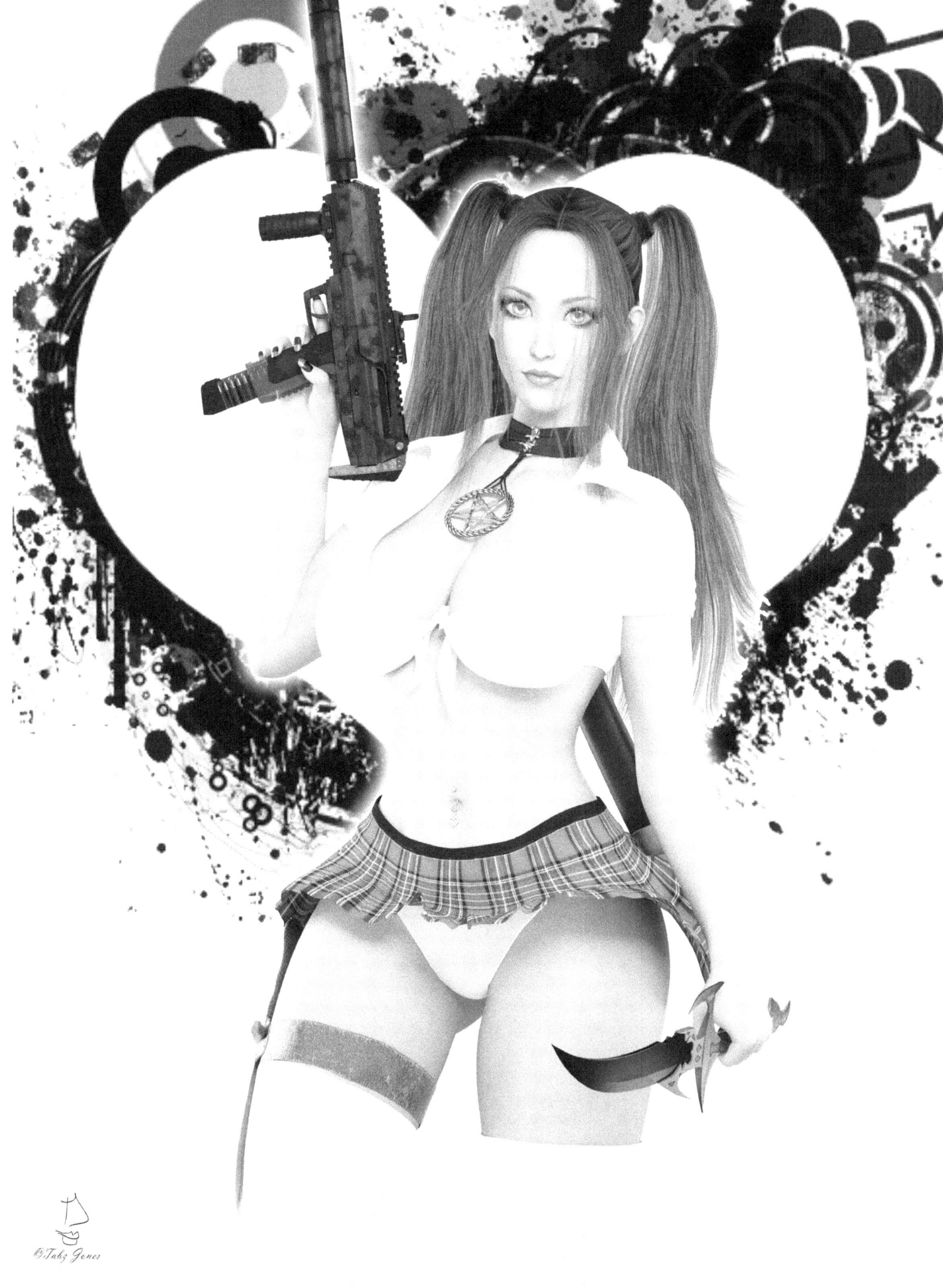

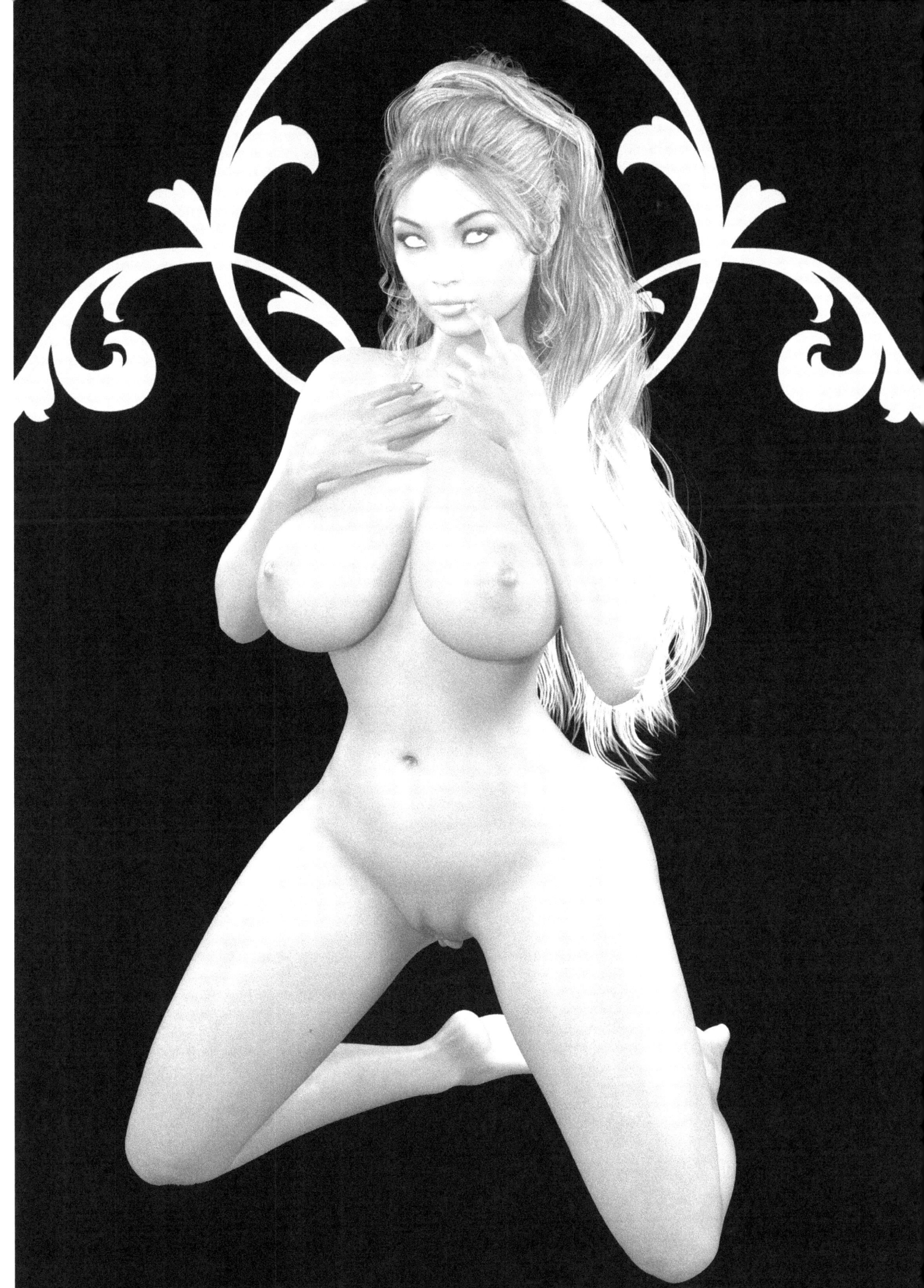

Thank you for your purchase!

To see the full catalog of my art, don't forget to stop by
www.gothictoggs.net

www.ingramcontent.com/pod-product-compliance
Lightning Source LLC
Chambersburg PA
CBHW080544190526
45169CB00007B/2631